The Girl

Who

Swallowed

Fire

A True Life Story

Iyatunde Cole

The Girl Who Swallowed Fire
Copyright © 2017 by Iyatunde Cole

ISBN: 978 9988 264406

Published by

Prekese Stories

An Imprint of Relight House Publishers
P. O. Box SK 583
Sakumono, Tema
Accra, Ghana.
E-mail: relightpublishing@gmail.com

The author has changed the names of persons and physical imageries, as well as some occupations, in order to protect people's privacy without injuring the story's integrity.

The author has made every effort to provide credits to authors and owners of materials cited in this publication whenever feasible.

Printed in the United States of America

Acknowledgements

"I appreciate you more because of the road I've travelled. My story brought me to you and I wouldn't' revise a word of my past if it led me anywhere but to your door."

—Aaron Polson

First and foremost, I am grateful to my ABBA—the one who told me it was alright to call Him ABBA! My Father, my peace, my Banner, my Healer, the One who counted me worthy even when I counted myself unworthy. The love you have for me, the grace you've bestowed upon me daily causes me to fall on my knees each day to appreciate you for all that you are to me. My life has never been the same since the day I said YES to you. Thank you for your protection even when I didn't even know you

were there. Thank you for your mercies that are new each day. Without YOU I would not have been able to complete this task. May I continue to give you glory for the rest of my days. I know without a shadow of a doubt that you are proud of me! I love you my Daddy.

And now to the beautiful souls who have been a tremendous blessing in my life? *Aaron Polson's* quote is perfect as it explains my heart and what specific people mean to me. My story indeed has brought me to so many of you and I'm grateful that ABBA saw it fit for every one of you to be a part of it.

Deckillah Omukoba my "Tandy" thank you so much for your contribution and your encouragement. You pushed me beyond the limits that I thought I was not capable to reach. Your vast knowledge in writing helped me greatly and I want you to know that I love and appreciate you. Thank you for praying for me continuously.

Apostle Raymond K. Akam "Papa!" It was in 2011 that we sat together in a meeting and I shared this project with you. What a blessing to have you be a part of my history. You have helped me in ways that I cannot fully put in words. Thank you for allowing me to vent, cry, laugh and even get angry sometimes, most of all, thank you for loving me.

Dr. Serita K. Wright "momma," my mission trip partner, the woman I know will fight for me no matter what. You are a great blessing in my life and I'm honored to have you in my corner.

Bishop Jonathan & Lady Irene Cole, what a journey it's been. Having you two in my corner has been a tremendous blessing.

Bishop Cole, the first person who financially blessed this project, thank you for believing in me and the work ABBA has called me to do. I love you for all that you are.

My beautiful cousin Rugiatu Sanu "Rags"; when I think of you, I combine both families together and

just you is enough for me. My family confidant, the one who I know fights for me at all cost. I love you so much and thank you for the standard you've set for me.

Daphanne McCray, my best friend and big sister. Twenty-one years of friendship! This journey has been amazing because you have travelled with me every step of the way. You know the depth of my heart, you've seen the transformation and I know how proud you are of this project. When I graduated from high school, you wrote in my year book and said I should take the word "CAN'T" out of my vocabulary, and that was because I had no confidence; I wasn't capable of achieving anything. But you helped build up my confidence, my self-esteem, and for that, I say thank you. I love you my dear one.

Rev. Deborah A. Cooper, "mother/The M" how did I find myself worthy enough to have a woman of your caliber, a woman with the epitome of The

Father's Heart—a woman with wisdom, and vast knowledge for the lost and broken!

I met you when I was at the point of giving up and questioning my faith and ABBA's love for me. Your wise counsel saved my life; you gave me confidence again, you made me believe that there were a few genuine ones that are positioned to help the broken and cast outs. Thank you for allowing me to watch you throughout these years and setting a great example for me. You have tremendously changed my life and I'm entirely grateful for you. You taught me how to raise my standard and know my place in the Kingdom. Thank you for always making yourself available when I needed to vent or express myself. I love you my confidant and secret keeper.

Paa Kofi Botchwey of Relight Publishing Company; The man behind this project, my publisher, the man who took this work with no reservations. I met you when I didn't know who

would take up this work and help me fulfill one of my assignments from The Father. You've had sleepless nights, worked tirelessly, even sick at times just to see this project complete. I love your story; I love that you were brave enough to share what God planted in you and your struggles. Your humility, integrity and character have been a blessing to me. You gave me confidence to believe in myself and what God has called me to do. Thank you for answering my texts, endless phone calls, answering the same questions over and over again. You were so patience with me during this project and for that I say a big THANK YOU! I look forward to working again and again with. Greater is in store for you my brother.

Foreword

The Bible likens Satan, our enemy, to a dragon. This dragon breathes out fire to devour and destroy any one destined to do great things for God (Revelation 12, John 10:10). They can choose to succumb to his venom and fire or capture it to use as a weapon against him (Psalm 19:13, Luke 10:19). Iyatunde has chosen the latter. She has risen above her jailor and oppressor of the past and elected to walk in the destiny her Creator originally designed for her. She has faced her dragon and exposed him for the true thief he is.

I am extremely proud of the strength and courage she has begun to walk in by allowing the Holy Spirit to have full reign in her life. Over the past

ten years, I have watched her cast off the masks of guilt, shame, fear, low esteem and feelings of unworthiness, to exchange them for His garments of Righteousness. What a glorious thing to behold, when God is transforming one of His daughters into the Bride she truly is. Knowledge, insight, and wisdom have begun to abound in her, as she was able to accept the love and grace the Father was holding for her. Many doors of opportunity have opened and now this next step of walking in victory has launched her to another level.

The masks are off. God has turned the fire of the dragon into a consuming fire of holiness against the enemy's lies and deceptions. I know her willingness to be open and vulnerable will be the catalyst for helping other young women, still trapped, grasp the courage to walk free of. Let her testimony be that witness to you. The first step is always the hardest, but as Iyatunde has demonstrated. When God is for you, who can be against you? (Romans 8:31).

Walk free off your jailor and begin to fly upon the wings of the Almighty. Soar above the low lands of limitation and boundaries. Open your eyes to see the vast opportunities of limitless blessing the Father has set for you. Set the fire in you free to annihilate the dragon.

—Rev. Deborah A. Cooper

Introduction to
Her Journey

"Courage is the most important of all the virtues because without courage, you can't practice any other virtue consistently." —Maya Angelou

Every journey begins with a *thought*. Every *thought* has a mission (what I call destination). The moment the *thought* comes to mind, you begin to make plans to get to its destination (fulfill its mission). Which means every *thought* is a *journey*. My journey began before the foundations of this world, before I was formed in my mother's womb. I was thought of by ABBA, separated for such a time as this to endure every obstacle and challenge life thrown at me. I was

matured at a very young age—and throughout my teenage and adult years, I understood the reason I was separated and thought different than my peers. ABBA began to prepare me for this task a long time ago. The journey towards getting to this point has not been easy but it's all been worth it.

It was six and half years ago when I sat in one of my counseling sessions, and heard these words: "God is going to use you someday to share your story and help others break free." At the time these words were said to me, I was not aware that it came directly from the throne room. I was in a place where it was hard for me to accept that ABBA would actually want me to embarrass myself in front of crowds of people and tell this story.

Six months past after this counseling session; The Father Himself spoke to me specifically and instructed me to tell my story, and use it to help others break free from the bondages they were in.

Again, I could not understand why He wanted me to embarrass myself in front of people like this.

"You will understand the reasons as you journey with me." He urged me on.

In my selfish thought, I began to make excuses. I gave Abba reasons why I would not be able to carry out the assignment which He had given me.

Years passed by and I could not rest in my spirit because there was this constant reminder of the assignment The Father has given me.

Every year ended with a reminder from Him, and every year ended with a promise from me; "Okay ABBA, next year!"

This cycle went on for about five and half years.

In 2015, I sat in my cousin's home in Maryland and decided to write. Within two hours, I had written a twenty page document of what ABBA was depositing in me. I was terrified when I reread what I had written.

"This is what I want you to write about!" ABBA said.

"Nope!" I replied.

Again, I laid this manuscript down and two more years went by. In early part of 2017, I journeyed to Sierra Leone, and my spirit was heavy during the trip. I could not understand what was happening—I was grieving in my spirit but I didn't know the reason. On my way back from Sierra Leone, ABBA spoke again.

"This is your season, write the book and watch what I will do!"

The way He spoke this time was different, I felt a sense of peace when He said, "This is your season!"

Back in the States, I began the writing journey once again. I sat down for six months, and wrote whatever He poured into my soul. Chapter after chapter, I wrote. And throughout the journey, He didn't stop depositing in me what He wanted me to share. This journey has been filled with fear, anxiety,

rejection, abuse and so on. But this time, I made up in my mind and understood time and season.

During this journey, I began to think about how people will respond to the instructions I was given by ABBA. I made people my primary focus and ignored ABBA as the one who had instructed me to start this journey. I have summed up courage in my own words. I hope my story does not only encourage you, but it also helps you to redefine your courage.

Welcome to my world, welcome to your season to break free from whatever might have trapped you—and, most of all, welcome to my ultimate obedience to my precious ABBA!

~Iya~

The greatest glory in living lies not in never falling, but in rising every time we fall.

—*Nelson Mandela*

The only tired I was, was tired of giving in.

—*Rose Parks*

The Lord GOD hath given me the tongue of the learned, that I should know how to speak a word in season to him that is weary: he wakeneth morning by morning, he wakeneth mine ear to hear as the learned.

— (Isaiah 50:4)

One

Our house was crammed between three different Mosques. About 5 o'clock in the morning, the Sheik's amplified voice ran through the streets like a sudden surge of electrical power, rushing into households in the dark, plummeting deep down the soul, waking the deeply asleep devoted ones—caring less whether you slept early or not—to come and pray. The voices of men who had taken up this responsibility of reminding people to pray on constant basis amused me. And each dawn, you

would see them patrolling the area similar to night security guards.

As I drifted back to sleep, I heard the loud cry of chickens in the courtyard followed by the barks of dogs, and the cows wrapped it with their trembling mooing. And from that collaboration of living and non-living things, noise infected the entire town and beyond; a new day was born, and with a new day came new struggles.

This was Fourahbay—my Freetown, my Sierra Leone. And these are the things I look forward to whenever I visit Sierra Leone, a country I'm very proud of and grateful to have been born and raised there; where I call *home* when I speak of *home*.

On the West Coast of Africa sits this beautiful country, surrounded by some gorgeous mountains, bordered by Guinea to the north-east, Liberia to the south-east, and the Atlantic Ocean to the south-west. She's blessed with a tropical climate,

with a diverse environment ranging from savannah to rainforests.

Sierra Leone is made up of four administrative regions: the Northern Province, Eastern Province, Southern Province and the Western Area, which are subdivided into fourteen districts. Each district has its own directly elected local government. Freetown located in the Western Area is Sierra Leone's capital, and also serves as its economic center. Bo is the country's second largest city. Other major cities in Sierra Leone are Kenema, Koidu Town, and Makeni.

Sierra Leone became independent from the United Kingdom on 27 April 1961 headed by Sir Milton Margai. The current constitution of Sierra Leone was adopted in 1991, though it has been revised numerous times. Since independence to present, her politics has been dominated by two major political parties; the Sierra Leone People's Party (SLPP) and the All People's Congress (APC).

It was quite an adventure growing up in Sierra Leone. We had the chance to wander about in forests like deer and grasscutters, swim in rivers like fish, and even sling birds, and climb up into trees to play, which was gratifying. Each activity gave us the knacks we needed in fighting for our future dreams.

My parents were not married when I was born, we remained with my mother's family until I was six years old, and during that time, my brother was born. After his naming ceremony, we moved to be with my father and his family. It was a bittersweet moment for me as I had developed great affection for my mother's family, especially my cousin, Rugiatu. For many years, I didn't know she was my cousin; I thought she was my older sister as we were very close growing up.

My parents were both working people. My father was a distributor for a soft drink & soda company called 7UP—traveling to the provinces to supply drinks, to small businesses in the rural parts

of Sierra Leone—a job he loved so much. During summer time, he would take my brother along with him on some of his trips, and you could tell that he loved the adventure; because he had the opportunity to spend quality time with his son and they bonded well during those times. We were always so excited when he returned home with foods such as fine gari from Bo, cassava bread and fried fish from Waterloo, fresh mangoes from Makeni, and fresh palm wine for his friends.

On the night of his arrival, our house was the place to be. His friends would lump together at the courtyard like bees and manufacture their own honey—jokes. And they would drink palm wine and tease each other, as my mother made some of her best dishes for them. My cousin who regularly came over during the holidays would help us to count loads of money that my father had brought home from his trip. And the two of us would drop a few Leones on the floor and quickly drag them under the

couch with our feet without mom knowing. We would wake up very early the following day to collect them before anyone came out of their rooms. We would be rich for a couple of days even though we could not spend the money publicly.

Another great incentive about my dad's job was that we had different kinds of soft drinks in our house. We didn't have to wait for a holiday to share a bottle of Coke, Fanta, or Vimto. Every two to three weeks, mom allowed us to share a bottle or two.

My father's traveling came to a halt when the civil war in Sierra Leone started. The traveling became so dangerous that we would be worried whether he would make it home safe or not. Because of this, our family plunged into financial strains, leaving us on the hooks of hunger—and this is why I dislike the idea of war, extremism, and the likes.

My mother worked for a shoe company called Bata Shoe Store. During those times, Bata was the place to shop when one needed shoes for any

occasion. Nearly everyone at her workplace loved her. We were blessed to have had her work in that company as we always had shoes on our feet. And I loved showing off my shoes when I was in school. Some of my friends who could not afford new shoes envied me.

Her company also had some great incentives that gave us opportunities to attend some great events, where we met prominent people we'd seen on television but hadn't met before. Having both parents working in Sierra Leone was a great blessing for the family even though they were not college graduates. Nevertheless, they were both blessed to have stable jobs that gave us quality lives. Bata was eventually closed, and my mom was blessed to land another job at the Sierra Leone Postal Service Limited.

I was about eleven or twelve years old when my parents got married legitimately. On their wedding day, because of tradition unbeknown to me, my

brother and I were not allowed to see my mother in her wedding gown. I was very hurt and disappointed that day. I remember hearing all the festivities when my parents came to my aunt's house for the traditional drinking of water. My brother and I were rushed to the back of the house, leaving me despondent throughout the day and even the next day.

My father is a Muslim and my mother is a Christian. According to tradition, my parents were not supposed to be married because of their different religious beliefs. In cases like theirs, my mother was supposed to convert to my father's religion after their wedding.

On their wedding day, they attended church first as a sign of respect for my mother's religion, which was supposed to be her last day in the church. Following the church wedding, they then attended the Mosque for the Muslim ceremony, a religion that she was to embrace starting that day. My mother, on

the other hand, did not convert immediately after the wedding. Owing to this, we were raised in a divided home, which complicated things.

The first few years of their marriage were challenging, especially for us the children. My brother and I were forced by tradition to attend Arabic school. Then on Sundays, my mother would take us to church. She was persistent about maintaining her Christian values.

Attending church escalated the discord between my parents, coupled with other challenges that were already going on in their marriage. Living in Fourahbay, a Muslim community did not help the situation either. My father's family whined about us attending church on Sundays instead of Arabic school.

These years were very confusing and hard especially for my mother who wanted us to know and develop a relationship with the Lord. I felt the effects of what was going on because I was old

enough to understand matters. My brother, on the other hand, loved attending Arabic school with his friends; I didn't treasure that notion. The only reason I attended Arabic school once in a while was that it provided me with the opportunity to leave the house owing to the strict nature of Mom.

I looked forward to Sundays more than any other day because I was able to attend church. There was something I experienced in the church, which I did not experience when I went to the Mosque; the Mosque to me was boring and too quiet. I didn't feel like I was learning anything from the Arabic classes. The only part I liked about the Mosque was when we sang, which was once in a while. No matter how often I attended the Mosque, I felt the same way all the time, like frying a stone in boiling oil—nothing changes. The stone is still stone no matter the hours it lies in the boiling oil.

The church, on the other hand, was the place for me. I wanted to do everything I could to know this

God who I had no inkling of, but had heard a lot about. I enjoyed the singing and the dancing. I enjoyed watching people speak different languages that I did not understand, yet felt some strange feelings when they spoke. I found satisfaction in a religion I knew nothing about. I loved that tingling feeling I was getting whenever I was in the presence of God, even though I did not fully understand what was happening to me; I was satisfied at the end of every service.

My father was not someone who punished his children by spanking them. The two or three times I remember my father spanking me was because I attended church. No Muslim child of his was allowed to attend church.

As the years went by, I went to church frequently, caring less about the consequences. I dealt with them as I could and when they emerged. Something so powerful was pulling me to this Jesus whom I knew nothing about. I was constantly

craving for more of what I received in the previous service. I was seeking, knocking and constantly wondering who this Jesus was and is—and funny enough I didn't know about Matthew 7:7 that says: Ask, and it will be given to you; Seek, and you will find; Knock, and it will be opened to you. I knew nothing about it, but I felt within me that I was missing something—something so precious, something so powerful. You could not blame me because I was in a constant battle in my mind as my life was oscillating from the mosque to Church, making it hard for me to concentrate.

Back in Fourahbay, we had a family that was renting one of our family's properties. They had a son who was a Christian. Because of my love for music, I was drawn to his radio, which was tuned to Christian radio stations almost every time he had it on. He had a cassette album entitled "Give Thanks" by Don Moen. During the weekends, as we did our chores, the entire "Give Thanks" album would be

playing, which gave me the opportunity to learn the words to all the songs. I would sit on the kitchen steps or the steps to his bedroom listening and singing to every song. Don Moen and I became best of friends without even knowing who or where this man was. His worship was and is awesome to this day.

> *"Give thanks with a grateful heart*
> *Give thanks to the Holy one*
> *Give thanks because He's given*
> *Jesus Christ His Son*
> *And now, let the weak say I am strong*
> *Let the poor say I am rich*
> *Because of what the Lord has done for us*
> *Give thanks!"*
> *— Henry Smith, 1978)*

This song was and is my anthem. I found myself looking forward to every weekend, hoping to hear my friend Don Moen's worship songs. On those steps during those weekends birthed my desire for

worship, and my relationship with Don Moen songs was sealed from that time. I would sit on the steps, yearning for more of this feeling, which I could not explain to anyone.

I found myself crying but I was not sad; I was overjoyed and the warm feeling on the inside of me was unexplainable. I could not explain what was happening to me during those times. I sang every Christian song I heard. And it was Pastor Karku, the man who used to play Don Moen's worship songs that officially introduced and led me to the Lord.

In an African home, relationship with your parents is mainly based on education, discipline and knowing your place as a child in the home. With my parents, it was a challenge. My father is not a communicator—someone who is able to talk about their ideas and emotions in a way that other people could understand. And so, my relationship with him as a child throughout my adult years was very challenging. We did not establish any father and

daughter bond that I had heard about. They say daddies and their daughters are akin to tongue and saliva—share an exceptional bond. That wasn't true in my case.

We had a strange relationship parallel to Tom and Jerry, and that made me think many times I wasn't his child, even though I grew up with him present in the house. He was silent in my life. At a young age, I felt he had rejected me. I say this because I saw how he loved my other siblings, witnessed how he cared for them that very much, but acted as if I wasn't in the picture, as if I did not belong. And on several occasions, he made it clear to me that I wasn't his responsibility; and I felt akin to tomato seed that had been disseminated in a fertile soil, and had been waited for weeks but wasn't germinating—totally hopeless. And that stuck with me for many years like the scars on my chest.

In my adult years, I silently began asking questions. I sought to know the reason behind his

rejection; why they could cast me out from a family that was supposed to embrace me, a family that brought me to this world, the very people I called family. Night after night I'd sit at the back of our house to weep. I would weep and weep and weep until the tears beneath my eyes had run out, and would fold my sorrow and sadness into a pillow and blanket—and the nights were too cold for me to bear. I would wake the next morning hoping to witness the joy that they say comes in the morning. Mine was the same sorrow and tears. I wondered whether I'd been cursed or was born that way, to suffer till I leave this earth.

I made an effort to seek help. Everyone I shared my pain with shut me down instantly, telling me I was not something they would waste their precious time on. I understood them. I had to understand them because, after all, what was so special about me? And so I became a good pal to silence. She was the only one I could talk to that

didn't tell me off or make me feel bad. And as a result, she swallowed me like fire swallows objects when you toss it into its endless mouth. Deep down I knew something was not right, but I was not in the right frame of mind to know what it was.

My mother, on the other hand, was the disciplinary type. She did all she could to make sure her children turned out to be the best—where the rules and regulations weren't enforced, she enforced them, and where there were no boundaries, she ensured there were boundaries, and you dared not go beyond them.

For this reason, she never allowed anyone one of us to go out of our home to play with our friends. You would have to tell her two weeks in advance about an event you would want to attend in three weeks' time. And within these weeks, you would have to be white as snow—good, extremely good. That means, you wouldn't have to get her upset; you do whatever she tells you whether you like it or not.

You weren't supposed to cause her to raise her voice at you or tell you to do something before you do it. She expected that you use your brain—be smart enough to know when to do what or else there was no way she would allow you to step out on the very day of the event. My mom did not spare the rod at any time. I received more whipping than any of my siblings.

This wasn't because I was a bad girl—the truth is I loved to play, and I could easily be distracted whenever I saw other kids playing outside.

Mom used the cane the way the tiger uses its roars to scare preys. And though its' prey gets a bit edgy sometimes; nonetheless, you cannot also say its preys won't go about doing their job or go near the predator again—they always do.

During the years of being at home, I shut down completely. I did the necessary house chores, minded my business, and did the best I could to make them as proud as was expected of me. I'm not

18

sure if they were ever proud of me; nonetheless, I think I did my best. I had to do my best because I came here to do my best.

Of the four siblings, I'm the eldest; I have two brothers and a sister. My brother, Abdulai, has a personality just as my father. He's more or less an introvert. When you ask him something, he answers you in a slow manner, ensuring his words are coming out like how a fowl lays eggs—one by one. My sister, Makallay, is a treasure. Ibrahim, the baby came when we were not expecting another child from our parents, but he's the life of the party with the oldest soul I've ever met. I love my family. In so many ways I wish things had been different with our relationship.

Two

Anyone who knows me knows I love music. My love for music has always been undeniable. I listen to different genres of music with country music being my all-time favorite. Kenny Rogers and Don Williams are my favorite country music artists. Whenever I find myself in a tough situation, all I need to rejuvenate is to listen to something from any of them. The soothing sound of their songs is a perfect comfort to my duress.

The voice of Celine Dion and the late Whitney Houston are remarkable. Both have this beautiful

way of making a connection so much that I can almost always hear their heartbeat through their songs.

There are so many other artists that I love and admire. My uncles introduced us to reggae music; and with reggae at the time, you could only cast your mind to Bob Marley, Lucky Dube, Joseph Hills—these legends turned out to be my favorite reggae artists.

Redemption by Bob Marley is such a powerful song. Paul Simon's Graceland album was always on replay in my house. The South African Mahotella Queens was also jamming in our house, making it seem as though my house was their studio, where they usually recorded their songs. But no, it's just that music is life to me and if the lyrics speak to me, you'd find me listening and dancing. And because of this love for music, I began creating this fantasy world in my mother's bedroom.

I would stand in front of her mirror with a comb or hair brush as "my microphone," singing and singing and singing, as though everything in the bedroom was my audience. The champion within me rose to her feet right in front of that mirror—that was my platform, that was where I became familiar with what I was born to do, discovered my God-given gifts.

I would sing as best as I could, and sometimes the ceiling fan, which had been dead for months, would start working. My entire world changed whenever I stepped into that particular spot. And this was a place no one else was allowed to enter.

On this particular day, I stepped into my fantasy world, as usual, holding my comb as my microphone, standing right in front of the mirror, set to sing.

If someone had warned me not to escape to my fantasy world and given me the reasons why I couldn't, I probably would've listened. The

atmosphere was eerie; I wasn't as sound or relaxed as I usually used to be. I started singing anyway, not minding whether someone was hiding listening or not—"I will always love you" by Whitney Houston. As I sang, with my eyes closed, feeding my soul on the soothing lyrics of the song, I felt a presence of someone in the bedroom with me.

I opened my eyes and saw this man, gazing and smiling at me.

As it usually happened, I thought he was going to get something in the room and leave, but he had become a statue, bonded to the door, gazing at me as if I'd changed so rapidly, or was performing some magic that he hadn't seen before.

"Um, Larison, please do you want something?" He stood there quiet and gazing me as if I were a tourist attraction. But no, I was just an ordinary girl, wearing my black skirt and blue blouse, performing on my stage. Because he was no stranger to me, I did

not make any big deal or care that he was standing there.

"I came for you!" He replied in a deep trembling voice.

I began shivering, similar to a cow that had seen a butcher with a sharp knife walking towards it.

"Take off your panty and turn around!" He said.

I looked at him, thinking he was joking.

"I said take off your panty and turn around," He repeated, and started undoing his belt.

"Huh? What does that mean?"

"Be quiet and do what I just said."

He turned me around, and suddenly bent me down and raised my skirt up.

"Please, Larison, pleeeaaasssseeee. I beg you, please don't hurt me…" I sobbed.

At first I refused but he firmly said, "You better do what I'm telling you or else…"

As a child who found herself in a very scary situation, I bent down. At this point, reality was

beginning to creep in. My world was about to change forever, my whole life flashed in front of my eyes. The man who was like my big brother, my babysitter, my protector, the one who I trusted was about to break my heart with a single act of selfishness. In the bedroom, in front of the mirror, in front of my audience, in front of my world!

In the bending position, I felt this object forcing its way into my body part. In pain I began to think and process what was happening to me. I couldn't move!! I could not fully comprehend what was happening! The pain was unbearable, one selfish push after another! Then another!

All I heard was moaning from this selfish man! At every selfish push, I was praying for death but it was so far away from me. When I could not hold my screams and pain in any longer, I shouted out so loud but to my disappointment, no one heard or came to my rescue. The only choice I had then was to wait for this selfish man to finish what he started. I

couldn't fight him back or run because he grabbed me tightly.

When he was done, he looked me straight in the eye and said, 'Don't tell anyone, or else I'll kill you…is that clear?"

I nodded in tears.

"Even if you go and tell anyone, I'll tell them you stole my money and when I caught you, you begged me not to tell your mom, so you said I'd do to you whatever I want." He added, as he dressed up.

He casually walked out of the bedroom after he had cleaned up his semen off the floor. I was in total shock of what had just happened. I could not face the mirror; I could not find my fantasy world to escape into it. I was shy, I felt too dirty. My life had instantly changed in a few minutes. I had just experienced one of many acts of selfishness from the same person who babysat me during my childhood days.

I kept asking myself: what just happened? What just happened? What did he do to me? Why is he so wicked? What the hell just happened to me? But no matter the number of my questions, he had already done it—already raped me. At the time, I had no idea what rape was, but I knew for a fact that I did not like what just happened.

My life had changed in an instant! The unexpected, the uncalled for, had happened. I had lost everything in that bedroom. And by everything, I mean, everything that makes up a girl. And it would take twenty years to find the real me. I was only fourteen years old.

As if that was the end of the tale. For a period of two years, Larison kept molesting me. I was never the same again. I was terrified of him. I hated when my parents were not home, especially during the weekends.

By default, he was our babysitter so he was always on me. And each time after he had done it

with me he would warn me if I ever told anyone he sure would kill me—and I would shut up until the next time he came around.

I didn't think anyone would believe me if I said anything. I knew no one would believe me as his voice was much stronger than mine in our home. So I believed him when he said he would kill me if I ever tried to tell anyone what was going on.

Hence, I swallowed the fire with the hope that one day someone would smell the smoke and call the fire service to come and rescue me—because, really, hell fire was all inside the belly of my soul.

There were days when waking up was a struggle because of fear. I was never aware when the violator would want to be selfish again. I was not sure who this God was at the time neither did I know His power or how to pray. The only prayers I knew were my mother's prayers I heard her pray and during my time in the Mosque. I had no one to tell this shameful secret to.

My mother allowed my friends to come to our courtyard to play because I was not allowed to go out and play with them. I looked forward to those times when my friends would come in and play with me, it gave me opportunities to be a kid and mingle with my peers.

Sometimes, I'd be right in the middle of my fun time with my friends, and the violator would shoot up like mushroom, whistling—a trick he became familiar with, which he made up purposely to signal to me anytime it was time for me to offer myself as a living sacrifice unto him.

As I walked into the house, depending on the spot he might have chosen for me to meet him, I would hear the desperation in his voice. I did what I was told, and every act was different depending on what his desire was. This was happening at least twice a week—taking complete control of what I was to do and what his pleasures were.

The violator had stolen my voice. He had taken away the very thing I loved to do, which was singing. That bedroom became my greatest fear! To this day, if and when I walk in that room I am reminded of that day, that day that my secret world could not even save me.

Within two years, I had lost my identity, my voice, and could not find any reason to function. I became rebellious—using all my time to play, and failed in school at the end of the terms, such that you wouldn't want to look at my terminal report cards for any reason.

I turned on a new leaf—became a liar, a very good liar. I lied to get out of every trouble or to even go out. I worked hard at failing at everything because failure was what my life looked like.

My mental, physical and emotional life had become infected by this toxic act. Being sexually molested had become part of my daily life, and I actually began to look forward to it. No, not because

I liked it, but because that was the only thing that was certain at the time. It was normal, I knew what to expect.

After I studied his pattern, I predicted the days, I prepared myself accordingly. I had no choice as this was the same man whom my parents trusted. They believed whatever came out of his mouth; saw him as a saint, the one who sits on God's right hand.

My parents believed he could protect me when anyone came attacking me; they were wrong. Behind the scene, the violator was killing me slowly. I learned how to pretend as if all was well; I was great at pretending and I wore it really well. This was the first mask I wore to cover the fire I was swallowing.

My heart was broken for all the right reasons, and my thoughts about men were toxic at a very young age. I had very low self-esteem even when I started dating, I felt like I had to do everything for the guy to accept me. I was a slave, in my own home, frustrated and confused. I had no idea where to turn

to, I felt stuck with this slave master. When would I put out this fire I'm swallowing? Who would rescue me? I kept wondering...

Three

The climate in Sierra Leone is tropical and humid throughout the year. From November to April, it is very hot and dry, with the sea breezes chilling the coastal zones. The dry, dusty harmattan wind blows from the Sahara in December and January, and you can expect torrential rainfall during the rainy season, which is between May and November.

The month of August is so special because there is a period called the seven-day rainfall, where the rains keep falling for seven days straight without

break. And this was my favorite season. I loved the smell of rain, especially when it hits the dusty ground, awakening that soothing and refreshing smell. Or when it gets you wet. And anytime the rains hit my body, it was as though freedom had hit me; because the rain has some sort of freedom—it beats the humble and proud at the same time. I come alive in the rain.

When I was growing up, I would dance and play in the rain. We washed our hair, clothes, and did just about everything in the rain.

On this particular day, the rain became very symbolic to me; I had created a getaway place in the rain, enjoying the freedom that rain brought. Rain needs no one's permission to fall. It falls wherever it decides to. When I stood in the rain, I understood what freedom was all about.

My life was in total chaos—dealing with family issues, dealing with rejection from parents, dealing with a man who was behaving like a monster. The

rain was my greatest door to freedom. When it rained, I was happy.

My mother did not allow us to go out in the rain all the time because we could get sick, especially when I was always sick of something. But the times that she allowed us to go out in the rain and play with our friends, I made the best of that temporary freedom. Sometimes it could rain continuously for days. Even while inside the house, the fact that I could hear the rain on the roof, or look out the window to see it gave me some sense of freedom.

In the second year of the abuse, it was raining on this particular day, and I was outside playing with my friends when I heard the violator whistling. As you know, it was time for me to offer myself again—time for him to molest me again—time for me to swallow another fire. This horrible tune that sounded like a monster was so upsetting. Again he was about to interrupt my freedom; be selfish.

Couldn't he see that I was having a great time with my friends? I thought.

Then came another whistling, this time lasting a little longer, signaling to me that he was really in the mood; but I ignored, acted as if I hadn't heard him. I was caught between freedom and bondage. When you are free, there are no boundaries. You dance like you are the only one in the room, you laugh with freedom.

When you are in bondage, you are sensitive to your surroundings. All of a sudden you become concerned about what others are thinking of you. I liked freedom better. In this moment, I began to question myself.

Should I go in and give him what he wants or I should just dance in this rain and enjoy my freedom? Do I risk getting into trouble again? Or should I just stay in the rain and ENJOY THIS FREEDOM? The thoughts spanned my mind.

The whistle began to drown my peace and the little freedom I was enjoying. I could hear the desperation in his voice and the whistle began to crack.

I was standing there, in that rain. In that moment, I had to make a decision. This was one of the hardest decisions I had to make. I just stood there, right in the middle of the rain; I felt numb, and my body was not responding, for a brief moment I was lost in total confusion. I stood still like a statue. I came back to reality when I heard the whistle again. I wanted to be free, and if I was going to be free, this was going to be the day. I began to feel like the prisoner I was because this man was tormenting me. This had to be my day to break out of prison.

The moment reminded me of my favorite television show called "Prison Break." I remember watching the episode of the day they were to break free. On that day, they stopped at nothing to leave that prison. They got rid of everything and anyone

who stood in their way to freedom. This prisoner "me" was desperate as well. And being desperate wasn't enough, because in "Prison Break" I learned that the prisoners took the risk. Meaning if we are ever going to do something great in this life, we ought to be willing to take the risk or we lose the chance. And with this wisdom, getting rid of anything and anyone in my way to break free was my focus.

I began making my way to his bedroom—his door was opened ajar. He was under his blanket. Desperation was all I could read in his evil-like face—and I could see him through the window as well.

I climbed the first step! Then the second, and right on the third, I froze! I couldn't move. It felt like something or someone had nailed me right there. My friends were busy playing with no clue of what was happening to me. I wanted to move, but fear had consumed me.

I wanted to go into that bedroom and let him do whatever he wanted to do to me, yet I couldn't move. Something so powerful was pulling as I tried moving. Boldness was rising in me—the champ within was awakening slowly whereas the fear that had incarcerated me was finding its way to wherever it came from. I then felt someone turning my whole body in the opposite directing, whispering to me, "Go, you're free. Go, you're free!"

I descended slowly to the ground floor, right back in the rain, to freedom—I felt like the wind blowing through his window, easy to feel but unable to grab in hand. I felt the rain so cool from my head all the way down to my feet. I did not look back to that bedroom to see what the reaction of my disobedience was doing to him. I danced even harder. Rain had never felt this good to me. I was free. Or so I thought. I was 16 years old.

The fear of getting in trouble with him or my parents was completely gone. The fear of being

molested was gone. The circumstances of my action this day did not hold me back. I was not held hostage anymore by this man and his actions.

Surprisingly, he didn't kill me, didn't even do anything to show that he was angry with me, as he had warned. He just went about his daily routine as I did mine. After that day, he tried getting me to perform the selfish acts with him, but I refused. Again, he did nothing about it. He tried and I refused, and this went on and on, but at every time I refused. Every refusal was getting me stronger. I began to think of him as a punk, and I began to feel disappointed at myself.

What if I had stopped him two years ago? Would things have been the same way like it was this time? I kept pondering.

He became scared of me as he was not sure of what I would do or whether I was going to say anything to anyone. But I was silent—I made no

noise about being molested to anyone. I knew too well how to pretend as if all was well.

As I look back today, I understand it was God who held me on those steps.

In the United States, there's a saying that, "We sweep everything under the carpet," which means, "The secret things you don't want people to know, you hide them." In my mind, I had swept those two years under the carpet. Life was back to normal for me, at least what I made it to be. I was going about my daily life, that part of my life was under the rug, in the closet, no one would ever know about it. Not in this lifetime would I ever open up and tell anyone about it. I, the "perfect" girl, the one with all the mouth, how could I allow this to go on for so long? So the perfect place to keep this secret was to sweep it under the carpet and no one would ever move the carpet to uncover the secret. Boy, was I in for a rude awakening?

Four

I could count the stars, I could see the sun, I could hear the birds tweeting and the trees waving, but, most importantly, I could hear myself singing. Life had gone back to normal after those two years of torture. I had hidden this big secret under the carpet, in a place where no one would ever discover.

There's no way I would ever disclose such shame and disgrace and bring embarrassment to my family. I was torn between thinking about myself, the

violator and my family. I chose the violator over me and how I was feeling. I found myself looking forward to Saturdays when I would settle on those steps trying to restore my love for music—listening to praise and worship by Don Moen.

The joy that music brings to my soul is unexplainable. Back on those steps again, back to that strange feeling that I could not explain to anyone, back to singing "Give Thanks with a Grateful Heart." What was I thankful for? My life was filled with so many secrets, I was struggling with wanting to be accepted; had absolutely nothing to be thankful for at the time but I sang all the same.

My family's life changed on this particular Saturday afternoon. My mother who was heavily pregnant with my sister came home that afternoon singing and dancing and flapping her hands in the air—extremely overjoyed. As she made her way upstairs, she called for my brother, my cousin and me, to follow her upstairs.

At first, as always, I thought we were in trouble for something. We followed her quietly; my heart was racing with so many thoughts. My dad was sitting in his favorite chair in the living room looking at us, wondering what was going on. My mother proceeded to pull out this piece of paper and started reading the content on the paper. It read:

"Dear Mrs. Cole,

Your family has won the visa lottery to the United States!"

Everyone was screaming not understanding what the visa lottery meant, but no one cared. The only words that were important to us was United States—U.S.A. When I was growing up in Sierra Leone, the United States of America was everything; everyone wanted to reside in the United States, and here we were, my family, my entire family having the opportunity to move to the United States. We were

all singing and dancing, hugging each other, and praising God for the opportunity.

By the time all the paperwork and interviews were completed, my sister had been born, and she was eleven months old. The day of our departure was nostalgic. My family was well respected in the community and having every one of us leave Sierra Leone on the same day left people with all kinds of emotions. Our street was filled with people, some crying, some cheering us on and some just looking as we left.

In the car that day, I left Fourahbay behind, I left that white house that had become a place of hurt behind, and most importantly, I left the violator behind. I was gradually erasing all those toxic memories from my head. I was free as I was going to a new country, a new place, to make new friends, and build a new home with no memories of my past.

There was no way I could even look back to be reminded of what I had left behind. America was

going to bring me joy, peace, and comfort that I desperately needed.

For the first time after a long time, I retreated back to my fantasy world. I saw my life in the United States. I was finally going to be this great artist I strongly desired to be at a young age. I was happy, life was great, and everything was perfect. My world had changed.

The entire trip was long and overwhelming but I didn't care. Waking up from fantasy world again, I heard the pilot over the intercom announcing that we will be landing in New York City shortly. The excitement was building up again. I was eager to get off the plane, to see the United States I heard a lot about and seen on television.

We landed in New York, September 19, 1996. Life was new. There we were—my family and I. Who would have thought that my family will win the America lottery and be granted a visa, which gave us the opportunity to move to the U.S? Had it not been

for God who makes all things possible, who else would it have been?

The airport was very crowded; everyone was minding their own business, everything was new to us. I had traveled before but this was my first time to land in such a big airport and to see so many people. After dealing with all the paperwork, we made our way to the exit where my dad's older brother was waiting for us.

The reunion with my father and his brother was very beautiful. He was so happy to see him with his family in the United States. I was happy when we made it to our new home. The journey had been long and hectic. But again, I didn't care. I had made the great escape from every negative thing that attached me to Sierra Leone. Welcome to the United States: the new chapter of love, heartbreaks, disappointments, failures, illness, and miraculous grace! As Ghanaians would say, "Akwaaba" to mean "Welcome!"

The first few months in the United States were stressful. I cried almost every day, leaving me ill. I was missing home, my friends, my first love and so on; it was obvious. We stayed with my uncle and his family, and they were very good to us. I remember running my uncle's phone bill to hundreds of dollars because I would always call my first love on Saturdays to talk—we stayed on the phone for long hours. Of course, I did not totally understand how the phone system worked.

About two years before we left Sierra Leone for the United States, I was dating and had fallen in love with a man whom I felt we shared mutual feelings. I loved and gave my heart to him because he was at the time the first man who had showed interest in me in a healthy way, and for all the right reasons at the time, I responded by giving my heart to him.

In this relationship, I gave my all. On the other hand, I saw his patterns and I was not given the same measure of love that I shared with him.

This was the man I called regularly. My uncle understood the situation and later explained the phone system to me in details. This man will later break my heart. We eventually moved to our own place after a while.

On my first day of school, I was a nervous wreck; everything in the United States school system was different from what I was accustomed to in Sierra Leone. In my classroom, I heard the sound of a bell, everyone stood up with a hand on their chest. I followed suit not understanding what was going on. I later found out that it was the pledge of allegiance that was being read.

Following the pledge, we sat down, and I was waiting for us to assemble together for morning devotion, to my disappointment, there was no devotion—again I found out that there were no prayers in public schools.

On this same day, we had what is called a fire drill. I heard a loud bell ringing; everyone stood up

and began to make their way out of the building, without asking questions, I followed behind. As I stood outside by myself, a lady walked next to me, in my head, I was praying that this woman would not start a conversation with me but it was too late to escape.

"Hi there," she said, smiling.

I wondered why she picked me to strike a conversation and not the other students. My English was not all that great, so I was very nervous.

"Why are you standing here all by yourself?"

I zipped up my lips, hoping she'd mind her business and just leave me alone.

"What's your name, dear?"

"Who is your dear?" I said in my mind, with my face frowned. She kept smiling and smiling as she drew closer.

"My name is Ms. McCray. I'm a teacher assistant in this school." She held out her hand. I gazed at her

wondering why she would not just move on; telling myself in my mind, "Go away. Go Awwwaaayyyy!"

"What's that your name?" She said.

"My name is Adiatu Cole. Today's my first day."

"Is it?"

I nodded.

She opened her beautiful arms and embraced me, petting me like some rose flower or puppy that her hubby had given her on her birthday or Valentine's Day.

By the end of our conversation, I felt my first day had ended on a good note. Ms. McCray helped me for the two years I was in high school, and we went on to become best friends to this day. She is my big sister and a mentor whom I love dearly, like how I loved the rains in Sierra Leone.

Five

America, as I've heard growing up, is the land of the free and the home of the brave. I was beginning to feel the freedom and the bravery in this country. I was living in the first world. The super power! Life in the United States had become somewhat normal, but what was normal anyway? I had made new friends, some genuine and some not so genuine, I graduated from high school and attended college.

The cupid of love had let his arrow out of the bow and aimed straight for my heart, with a single

strike. I fell in love with this wonderful man. I gave him my whole heart and things were looking okay.

My family was doing well and we had all adjusted and adapted to our new life in the land of opportunities. My life at this time was beginning to go down in a spiral very quickly. The incident in Sierra Leone was swept under the carpet; my mask had perfectly fitted on my face and I knew it would never come off at any time. I had completely lost sight of who I was, and even if the real me appeared I would not recognize her. America had become my safe haven, my escape, my sanctuary city, and my hiding place.

If you've ever been invited to a masquerade ball, you know that one of the criteria to attend the ball is to wear a mask, right? With this mask on, people cannot recognize who you are unless they know you personally acquainted. The mask I wore at this point in my life never came off and what others saw was

what I wanted them to see. Their recognition of me was that of this "perfect girl."

This man I was dating at first showed me great love and respect, and I loved him as well. I had no idea what true love was—this was the first man who showed me what I thought was love—and so, I was willing to give him everything he wanted with no reservations. And the "Perfect Mask" was still on.

Already, I had suffered heartbreak from three different men whom I trusted before, and was fighting hard for this one not to be the fourth. The first man who broke my heart was the violator, then my father, then my first love in Sierra Leone.

There was no healthy relationship between the men I trusted and myself, especially the ones who were to protect me. Everything I thought was normal at this time was toxic.

As my relationship with the man progressed, so was the pressure for sexual relation. The excuses I came up with were not helping my situation. Sex or

the thought of it at the time was a reminder of my past and of the man who had introduced it to me wrongly.

I pleaded, cried, gave excuses but to no avail. There was no one to talk to; I could not go to my parents for advice because sex is not up for discussion especially in an African home.

One of the biggest taboos in an African home is the discussion of sex between children and their parents. Our parents failed us by not giving us the assurance that it was okay to talk about it. In an African home, a child is expected to attend school, get the best education, and that's it.

Growing up in my parents' home, I never saw the green light especially from my mother to talk about anything. Because of this, at a very young age, I was completely shut down from discussing anything with my family.

The first time I had my menstrual cycle, my mother gave me the "talk" by telling me that I would

get pregnant if a man simply touched me, and she demonstrated this by touching my arm. I was old enough to know that's not how you get pregnant but I played along with her "talk." I do not blame her entirely because I'm sure that's how her mother raised her. My mother never talked to me about boys; all I knew was that I was not supposed to have a boyfriend. Period.

My father and I had absolutely had no established relationship like I stated earlier, and so he had no interest in telling me what was good and what was bad.

Even though I grew up with him, I've always felt like an outsider, so forget looking up to him to teach me how men should treat women.

During one summer break in Sierra Leone, I had a neighborhood boyfriend. We were kids growing up and we were attracted to each other. All we did was sit and talked for hours. Because I was not allowed to

have a boyfriend, it was top secret and no one knew about him.

On this particular day, my uncle happened to see me coming out of his house and this individual was behind me walking me out. Right there, on his steps, I knew I was dead when my mom gets home, knowing very well that my uncle was going to tell her what he'd saw.

As I perceived it, when my mom got home, my uncle told her what happened. My mother called me into her room, and right next to her was her cane, some water, and some cayenne pepper.

The cayenne pepper—also known as the Guinea spice, cow-horn pepper, red hot chili pepper, aleva, bird pepper, or, especially in its powdered form, red pepper—is a cultivar of Capsicum annuum, which is related to bell peppers, and others. And it is a very hot chili pepper used to flavor dishes and named for the city of Cayenne, the capital of French Guiana.

I stood in front of her as she was trembling, mixing this concoction. Then she paused. "Are you sexual active?"

I said no. I was telling the truth, but according to her, it was a lie.

"Take off your dress and lie down on the floor."

"Mama, but why? What did I do wrong?"

"I said take off your dress and lie down on the floor and open your legs...very wide."

And by this time, she'd finished mixing the cayenne pepper with some water, too. Before I knew it, this hot pepper and water were dashing in my private part, plus the cane hitting my body so hard that I could feel the excruciating pain of every ounce. She asked me the same question over and over again, and I repeated the same answer, "I was just coming out of his house. We didn't do anything."

She felt we were automatically in there having sex—doing what only married people are allowed to do. My mom gave me one of the worst

beatings that evening all because my uncle had told her that he saw me coming out of a guy's house. That was one of the many ways and means mom talked to her children about things they were not supposed to do.

In so many ways, I wished I was able to talk to my parents about the things that were happening to me. And, because they didn't create the atmosphere for me to be free, I shut down completely again.

Please don't get me wrong, I'm not taking away the fact that my parents did their best in raising us, and they did it the best way they knew how.

Six

I was a damsel in distress. I needed a hero to rescue me from the ghost of my past, and I thought Mori would save the day. My relationship with him was what you could call somewhat normal in the beginning. I was always aware of the fact that what we were doing was wrong in the eyes of God. Fornication and so many other things we were involved in were not right. But, because I was infatuated with the promise of marriage and afraid to lose the only person whom I thought loved me, I

could not stop engaging in sexual intercourse with him.

One evening, during our sexual adventures, I could feel the past swept under the carpet forcing its way out from under the carpet. My big secret was about to be revealed. Mori was doing some things to me that triggered memories of the violator. Instantly, I jumped out of the bed, crawled to the corner in a fetus position. I was crying, he was nervous not knowing what to do or what was wrong with me.

That day, the carpet was raised all the way up, for the first time, I saw this man as the violator, I had a flashback, and my past made its way to my present. At first, I said nothing; I was silent for a while until it happened again.

This time, I had no choice but to explain what was going on with me. I told him everything that had happened.

At first, he was quite upset and showed great concern and affection toward me. I felt great

because, for the first time, I felt like someone understood my pain. For the first time, I felt free, but that did not last long.

How is your past affecting your present life? Have you ever been in a situation where your past is constantly haunting you? My past began to haunt me; I was in situations where I was constantly reminded of my past. Every sexual act with this man became a constant reminder of what had happened to me before. I was having flashbacks of the violator. I began to feel his presence, smell him on this boyfriend, the pain and torture became unbearable. Everything in this relationship began to go sour.

My boyfriend constantly reminded me that he was not the violator, but I could only see him as though he was. It was painful. My past had packed its own suitcase and followed me all the way to my place of escape. It had followed me all the way to the United States; the sanctuary I thought I was keeping sacred was invaded with this toxic memory.

I became desperate again, confused, not knowing what to do. I reached out for another mask, this time, every pain was bottled inside. I shut down sexually. I was not doing it for pleasure, not that I knew what pleasure in sex felt like.

I gave this man total control of myself. He had the pleasure of doing whatever he pleased with my body, there were no reservations.

There was no way I was going to lose the one whom I thought loved me, so I was silent and went with the flow.

My relationship with this man began to go sour; there was cheating involved, physical, emotional and verbal abuse was introduced because of jealousy.

During this time, I lost all self-esteem, lost all confidence in myself, lost all the hope that I had. This man that I trusted, this man whom I thought loved me, was breaking my heart into pieces. We became obsessed with each other for different reasons. I was looking for a father in this man; I was

looking for a big brother; I was looking for a friend—and ultimately I was scared.

His reason was that he could not stand the thought of me going with anyone else, so he shot negative words into my soul. "Look, girl, no man out there would ever like to come around such an ugly thing like you."

His words broke me down emotionally, physically hurt, and incarcerated my mind for a very long time. I was emotionally scared, physically hurt, and badly beaten on some occasions.

On two separate occasions, I thought I was going to lose my life in the hands of this man. One evening, I was accused of messing with someone, when I was the one who said this individual was making passes at me. Of course, I was the liar in the situation. This man started beating me in his bedroom, slamming my body on the concrete floor of his basement, my neck hurt very badly that I got

extremely scared, to the extent that my dress was ripped from my body.

As I made what I thought was the ultimate escape upstairs, he followed me, pulled a kitchen knife from the counter, forcing me to run out of the house with just my bra and pants on. He eventually allowed me back in the house. I asked one of his sisters for a t-shirt to cover my nudity. I was starting a part time job that day with pain and tears in my eyes.

With my mask on, I went to work, but I could not stay at work because he followed me there and before I realized, he was deflating my car tires. I came out, drove the car to a gas station, and called my friend Daphanne, crying for help.

She ordered me to go to the emergency room, which I was scared to do because I didn't want anyone to know what had happened to me. Daphanne met up with me in the ER, and she witnessed the bruises, inflamed ribs, and a swollen

neck. This man almost paralyzed me that day. Daphanne took me to her priest following the emergency room visit. I was in total shock and could not even remember what the priest had said or what was happening to me. I went home silently, said nothing, took a shower, and went to sleep.

The following day after classes, I was back into his arms after some apologies, with some flowers in my hand, and sweet words on my lips. My father used to say whenever he saw gifts from this man, he knew there was a fight, but what my father did not know was that there were physical fights involved.

The second dangerous beating occurred when we were on our way back from his parents' house following Thanksgiving dinner. A simple conversation had turned into a big argument, the big argument then turned into a physical fight. My head was being slammed on the dashboard, then on the shift gear of the car. As we made our way to his house, he dragged me out of his car through the

parking lot and into his bedroom. I remember seeing his roommate's girlfriend and her friend in the kitchen and watched what was going on without saying or doing anything.

In the bedroom, he stomped on me, slapped and kicked me around. I passed out on the floor when I came back to my senses; he was standing over me trying to wake me up with a cold compress. Before I could move, I heard his sorry excuses again, and again, I forgave him. I had become a battered woman. I had become a woman who thought physical abuse was okay. I had become a woman who was terrified of her boyfriend. I had become a sad and unhappy woman.

Two years had passed by and I was still in this unhealthy and abusive relationship—still swallowing this fire. My mask was still tightly fixed on my face, ensuring it would not fall.

I've had a different mask for the different tragic events that were occurring in my life. The only one

who knew some of what was going on was Daphanne, and she only knew what I shared with her, so even my best friend did not know much of what was happening to me.

Then it happened. The ultimate thing happened—my worst fear had come to pass. I missed my monthly cycle; the pregnancy test confirmed that I was pregnant. PREGNANT? "Me, Adiatu, pregnant?" I screamed. "Me, Adiatu, pregnant? What am I going to do?"

At my age, I was still in college, and not married; there was no way I was going to have a child unmarried. The other sensible thing that came to my mind was disgrace (I will become a disgrace to my family)—I was pregnant at this age, not married, not sure of what the future was going to be like.

Keeping the baby was not an option neither was it up for discussion. A family friend of ours found a place I could go and get an abortion. That abusive man, together with our family friend took me on a

Saturday morning and just like that, the baby was gone. Months after the abortion, I was still crying almost every day. I didn't know I was suffering from Post Abortion Syndrome (PAS). I killed a seed, I broke God's heart, I, the perfect girl had committed murder. I was devastated and was not the same again.

After almost a year and a half later, things got back to what seemed like normal—the same abuse continued. This time, I did not know who I was; I could not recognize myself anymore.

Eventually, I made up my mind to completely walk away from this relationship. Another heart break. The people who knew we were together were in shock when they learnt of the breakup because all they saw was this "perfect" couple. No one knew the truth behind the breakup and what the reality of the relationship was. I was blamed for the breakup, even my parents supported him. No one was on my side at the time. It was very hurting.

I was scared for my life, I wanted to run away, I was crying for help right behind that mask but, of course, no one heard me. Six months after the breakup, we tried to work things out, big mistake! At the time, I was involved in many things I had no business being involved in. Slept with this guy again, and I missed my monthly cycle the following month. I was pregnant again.

Again, the same two people took me to have another abortion. I remember this man begging me this time around to save this child, but I refused. My refusal this time was based on the fact that I was not sure who the father of the child was! Of course, the perfect girl was not about to have a Maury Povich moment.

This breakup season was rough. Mori began to stalk me. He would stand by my bedroom window making threats of killing me because in his words "if I could not be with him, I could not be with anyone

else." I was in constant fear, looking over my shoulder wondering if he was there.

Months after we broke up, I later found out from his former roommate that he had bought a gun, had gotten drunk one night and was going to my house to shoot and kill me because I had left him.

Years later, he had confirmed this story to me. Thank God for his roommate who saw him leaving drunk that night and frisked him for his keys to find the gun. I could not have died, I had a purpose. I swallowed yet another ball of fire, chocking in smoke. Silently.

Seven

Have you ever been trapped in an elevator, your cell phone had no service, and the only means of communication available to you was that one emergency button that reads: "Pull In Case of Emergency"? As you pull the button, you begin to wonder whether the call for help was received in the first place. The feeling of helplessness starts to torment you, as you begin questioning whether you'd ever find your way out alive or not. And it's extremely fretful when it happens that you are the

only one trapped in that dark elevator, waiting impatiently for help to arrive. You pace up and down, left and right in that small space, worried. That was how I felt. And the worst was that, in this elevator, there was also fire, which I had to swallow.

I realized if I was ever going to come out of this elevator, stop swallowing this fire, then I needed someone with deep knowledge on how best to get someone out of a trapped elevator. I mean, if really I needed freedom, then I needed to get someone to help me.

And the funny thing is, when I pulled the emergency button, there was no one to come to my aid. And so, I became impatient—my closet was beginning to overflow with these masks, which I couldn't close any longer. I was on an emotional roller coaster—one day I was up, the other I was down then the other I didn't know what was going on. My friends and the people around me thought I had it all together; became the life of the party; but it

was just the "Happy" mask on, which was all I could do to get the attention away from me.

In my waiting period to be rescued, I had to look for another identity, another place to hide. Finally, something jogged my memory to go to church. I was hoping to rediscover my worship and get my voice back. I was hoping to rediscover the worship that was birthed on those kitchen steps in Sierra Leone. And there I was, sitting on my chair in the tenth row, praying and asking God for His forgiveness.

And then it started. Men in the church began to make passes at me, leaving me dumbfounded. Married men of God and respected leaders in the church were approaching me with all kinds of offers. I was hurt, broken, disappointed, as I thought this was the place where I could go to, to get the help I so needed. The place where I was hoping someone would notice that I had pressed the emergency button for help and had become another elevator I was trapped in, another fire to swallow.

So, I became a church-hopper, so to speak—I was hopping from one church to another, and the same thing was happening. Even though I wasn't so much aware of it, but I was asking, seeking, and knocking just as Matthew 7:7 commands, but no one was inviting me to come in, like how Revelations 3: 20 professes, "Behold, I stand at the door and knock. If anyone hears my voice and opens the door, I will come into him and eat with him, and he with me." Sadly, I could not find anyone in all the churches I'd been to, to 'invite me home" – "Bring me to the throne of grace, where I could receive my healing and renewing of life."

It's a dangerous thing to be part of a congregation where your leaders are not sensitive to the voice of the Holy Spirit to recognize that God's children need help sometimes. My hatred for men grew stronger. Men became my greatest enemies. Every man that I knew had broken my heart. I was in and out of relationships.

Whenever a relationship looked like it had potential, I ran from it. I was afraid because I knew no one wanted me. I had unconsciously become the abuser—the abused was now the abuser.

In the midst of this chaos, fear, and confusion, I was introduced to women—I became a lesbian. At first, it was very uncomfortable to get involved in yet another toxic relationship, but I became comfortable very fast. I enjoyed the attention, the benefits, and control I had in these relationships.

For once, I didn't feel pressured into doing things I didn't want to do. I was in total control. That perverse appetite spirit had taken complete control of me—I was helpless. The enemy was trying to destroy my purpose, my destiny, my future and ultimately my soul. He lost this one to ABBA.

The first woman who presented herself as a mother figure was the woman who made sexual advances at me. The attention I received from this woman was overwhelming. For the first time in my

life I felt important, I felt wanted, I felt like I mattered, and I loved the feeling of being wanted. This unhealthy relationship felt normal for years and women became my priority.

My former boyfriend during the time of our relationship suspected I was involved with women—(woman and woman) having sexual intercourse with the sole aim of satisfying each other's sexual needs. With this information at hand, he began spreading the rumors about me in our community; and it took an entire year before I was aware of the rumors. People were talking about me behind my back without my knowledge. Every waking moment became a battle. The community was talking about me; fingers were being pointed at me whenever I attended a gathering. Parents would tell their daughters not to be friends with me. Everything was falling apart again—my community, my village had stopped raising me; instead, they were burying me deeper into the ground, alive. The

ground was closing in on me; the elevator became darker, and the call for HELP had disappeared, I swallowed in pain. The mothers were talking about me.

There were times I had to confront some people because their chatters became unbearable. No one ever saw me in the act with another woman because I was conscious of protecting those I was involved with and myself, but they were making up so many stories about me. The lies people told, the people they were associating me with, was just horrible. This season was cruel. It wasn't that the rumors were all false; it was the manner in which some were talking that left a bitter taste in my mouth to this day. I forgave!

I was in for a rude awakening when I woke up one morning. As I sat on the edge of my bed, I heard myself saying, "Maybe I was born this way." I was coaxing myself to accept the fact that because I had been through so much with men in my past, women

were the best option for me. The enemy was in my ears this particular morning. He was telling me lies about my identity and future. The voice was telling me that men will never love me and I should just become a lover of women. The devil's voice was blindsided by the voice of the Father who began to tell me that I was not born to be a lover of women. I was not a lesbian, bi-sexual or what have you. I was a battered woman who was seeking love in every way I thought I could.

That morning was the day I made a decision. I made a decision to walk away from the toxic relationships I was involved in. The decision left those who I was involved with angry. I was selfish they say.

God made man in His image and likeness after He created man; He looked and said it was not good for man to be alone. He put man into a deep sleep and created woman to be a help mate for him. He would have created another Adam if it were okay for

the same sex to be lovers of themselves. He went on to say for this cause, the man ought not to be alone—a man should leave his father and mother's house, cleave to his wife and the two shall become one.

That was the day I realized that no one is born gay or lesbian; it is a spirit that grabs hold of people, controlling their thoughts and causing them to think otherwise. Like my story, there are a lot of people who have been through so much with the opposite sex, and because of their tragic experiences, they are desperately seeking attention and they gravitate to the first thing that looks and feel good.

No matter how rotten we are, God is able to restore us and use us to rescue people like us. And that's what inspired me to share my story with you.

Eight

Have you ever spilled something (such as tea, coffee, food) on your carpet, and immediately, you were frantic, going the extra mile to clean the spot in order to prevent it from possible stains and odor? Did you feel the overwhelming sign of relief when it was finally cleaned up? You look at the surface and it clearly looks clean and dry, and then you go about your daily routine overlooking the spill or assuming it never happened.

Days later, you walk into your house, you are greeted by a nasty odor that have overtaken the

whole house; frantically, you begin to search for where this nasty stench is coming from. You check from the bathroom, the kitchen, looking in the trash, in the fridge for spoil food, then to the garage but your search is of no use.

All along, the food that was spilled on the carpet is where the stench is coming from; meanwhile, your focus would be on something different. The carpet would be lying there quietly, looking at you running to and fro, as you try hard to figure out where the smell could be emanating from.

And sadly, the carpet won't yell to you, "Hey, it's me, you only cleaned my surface but I had sucked some food to the bottom." It would just quietly lay there silently watching you frantically sniffing for a smell. Again, you're frustrated because you thought you had worked so hard to clean the spill some days before. The work that seemed so easy has now become a big job. You will have to shampoo the whole carpet to get the stains and the smell out.

My life had become like that stinking carpet. On the surface, I looked perfect, everything about me was together, but on the inside, everything that was swept under the carpet was releasing a nasty stench. I was stinking so badly, and I couldn't even run away from myself, if I had the opportunity to do so. I was decomposing slowly and no one was there to resurrect me. Depression, sadness, loneliness, rejection, mood swings, stress and so much more were all interrupting my daily life. I was mentally sick, and hid that from friends and family for so many years.

I was fighting so hard to be strong, to have it all together, I made myself available for others to dump on which allowed me to ignore my issues temporarily. Sexual abuse, unhealthy lifestyles, abortions, abusive men and women had caused me to lose my identity. No one knew that I was silently dying.

There were just speculations—people guessing and making things up about my life. Most times I found myself having to defend myself from what people were saying about me. I needed to reach back to the closet and get another mask. Even the masks on my face were beginning to smell but I could not take them off. Reaching to the already overcrowded closet, I quickly grabbed another masks. These are the mask that almost killed me.

In 1999, I had my first open heart surgery; between 2005 and 2009 I had suffered multiple back injuries. I was involved in three car accidents, all of which affected the left side of my body, especially my back. I was in constant pain from these injuries. I was diagnosed with herniated disc, my left hip was twisted. I had sciatic nerve damages and so on. I was on a ton of pain medications.

Around this same season, alcohol had become common to me. One pill after another, one alcoholic beverage after another, I began to love the way the

pills and drinks made me feel. One pill after another, I was temporarily numbing my pain and hurt. Partying, I would find myself drunk, driving home drunk, and I didn't mind.

On two separate occasions, I found myself on the other side of the road, not even sure of how I got there or how I made it home. But despite all these, I had a purpose, there was a destiny waiting for me to fulfill—death was not an option, because, God's grace covered me all the time. I was hiding alcohol in my bedroom under my bed, drinking myself to sleep, or would take a pill, and sometimes both. I needed to forget what was real because real was not a place I wanted to be. Reality hurts; reality had a lot of nasty memories.

I had become a functioning drug addict, taking pain medications all day just to make it through. The emergency room had become a revolving door for me, the moment I was running out of these pills, and couldn't go to my doctor, I was in the ER

complaining of some type of pain, and because I had a history of all these existing issues, I would be given the pills. I was functioning as a worship leader, serving my pastors, traveling on several mission trips, seeing soul saved, feeding the hungry, and so much more—and yet, I was dying, no one noticed! If they did, no one said anything. I had become a drug addict, a junkie, living this dirty lifestyle, which made me numb, sucking all my hope, just decomposing. I searched for the meaning of Childhood Sexual abuse and its effect, and here was what I found:

"Childhood sexual abuse has been correlated with higher levels of depression, guilt, shame, self-blame, eating disorders, somatic, self-blame, dissociative patterns, repression, denial, sexual problems, and relationship problems.
—(Article 19, The Long Term Effects of Childhood Sexual Abuse: Counseling Implication by Melissa Hall and Joshua Hall).

The above is just a handful of long term effects of childhood sexual abuse. Unfortunately, I was

dealing with almost all of what is listed above. The feeling of constant guilt was always present in my life. I felt guilt and shame because of the way my life had turned out to be. I was a disappointment to my parents.

Of course I was on a dangerous path, in complete denial, I had shut down everything that looked or sounded normal. I was worthless, had nothing to offer to anyone. Again, children who are abused sexually grow up depressed. And I was the perfect definition of it.

"Depression is a mood disorder that causes a persistent feeling of sadness and loss of interest. Also called major depressive disorder or clinical depression, it affects how you feel, think and behave and can lead to a variety of emotional and physical problems. You may have trouble doing normal day-to-day activities, and sometimes you may feel as if life isn't worth living."—By Mayo Clinic Staff (www.mayoclinic.org).

During the research for this book, I have discovered a lot of things especially on depression. I have been depressed for a very long time. The moment I was sexually molested, I became depressed. I was not me anymore. The energy it took to cover up the hurt and shame was depressing me. I was always sad because happiness was so farfetched from me. The feeling of hopelessness was present for many years. I felt like I did not matter, that I was hopeless to society.

My heart had been broken into so many pieces and putting it back together was an impossible thought. In some instances, I was cruel to people around me. I was depressed, severely depressed. I was not able to snap out of it on my own, not even God could convince me enough that I was worth anything to Him. I could not identify with depression then, because I was not aware of these symptoms. "Depression is not a sign of weakness,

it's a serious mental health condition and survivors can often benefit from the help of a professional." By RAINN (Rape, Abuse & Incest National Network)

I was beginning to blame myself for the way my life had turned out to be. I had suicidal thoughts, which I shared with my best friend and she only did what she could to help me at the time. I had nothing to live for, so dying was my only option, so I thought. I was mentally sick. Who would even begin to take me serious if I ever exposed myself to them?

I began to suffer from anxiety, and even I had anxiety attacks and phobias. I couldn't sleep in the dark, was uncomfortable when men hugged me because every man was a reminder of the ones who broke my heart and violated me. I could not sleep in the dark because horrible things were done to me in the dark, and it was a constant reminder of my past. I traveled with people and they could not understand why I had the lights on at night. I could not tell them,

so I re-adjusted the mask again. I was becoming exhausted from keeping my secrets, my closet, the carpet—everything was attacking me; I was choking from the black smoke. I needed another escape, a harmless haven, somewhere to call home!

Nine

Still trapped in that elevator, waiting to be rescued, mask tightly fixed in my face, stinking carpet drenched with so many secrets—I felt like I was running out of help. I was having constant anxiety attacks, was walking in constant fear, fear to get help, fear to be stereotyped by society but most of all, fear for my life. I needed help, and my cry for help had become louder and louder. I had become obsessed with ministry, basically living in the church I served at the time. I was still seeking, knocking and

93

to no avail, there was no invitation to come in. ABBA finally sent help. My help came in a unique way.

My help came through music, through worship, through the very thing that was birthed back in Sierra Leone many years ago.

In 2007, my former pastor introduced me and the rest of our worship team to Rev. Deborah Cooper. Rev. Cooper is a worship leader and a teacher who was going to help our team with voice training and understanding the heart of the Father through worship.

There was something different about this woman. I paid close attention and grabbed every word she had to say on worship. Her view of the Father's heart and teachings were all new to me. My understanding of worship was nothing compared to what she was teaching. I became drawn to this woman, as she had something I had longed for—the heart of The Father. I was beginning to hear about

ABBA'S love for us, and not His wicked punishment and judgments, completely different from what I was used to.

For the first time in over ten years, I felt some sense of comfort through her teachings. For the first time, ABBA took me back to those kitchen steps where He originally birthed worship in me. After listening to many teachings, my life began to transform; ABBA had sent help through worship; I was happy!

Rev. Cooper's assignment ended after about six months of mentoring our worship team, leaving me devastated when she told us she was released from the assignment. I did not have a vast knowledge of spiritual things at the time so it was hard for me to understand why she had to end the assignment. Before she left, she gave me her business card and told me to call if I had any questions regarding worship. That business card became my lifeline. Months had passed by, I was beginning to retreat

back to what was normal and I began to look for another mask but this time around, I could not find a new one that could identify with what was happening with me.

My desire to break free became a constant thought. Day after day I struggled to unmask, struggled to put this fire I was swallowing off, but I was afraid. I went back to Rev. Cooper's teachings, reread her book on worship, and then I remembered the business card. At this time, I didn't know she was a licensed Christian Counselor; all I knew was that she was the music director for her church. I reached for the card on one challenging day; I had no question on worship but I had to call this woman. This was one phone call that was going to save my life.

As I placed the call, on the other end of the receiver, I heard, "This is Rev. Cooper, how may I help you?" I completely froze. Then I began to sob bitterly, my silence was an indication of regretting I

placed the call, but my sobbing was an indication of peace and the thought of finally meeting someone that had asked how they could help me.

Rev. Cooper waited patiently until I comported myself and was able to finally speak. I expressed that I needed to come in and discuss some things with her. She set up an appointment with me, I got off the phone, and I found myself swimming in this river of peace.

The days leading up to my meeting with Rev. Cooper, I was contemplating canceling the appointment or not showing up at all. There was something on the inside of me that prompted me not to cancel the appointment. My first meeting was a challenge, I shared bits and pieces of what was going on with me, and some of the things I shared that day were not even relevant but that's all I could do to keep the masks on.

I was very confused because my mind was messed up with lies of this "perfect girl" mentality,

and, I was scared because I could not trust this woman to tell her my secrets. I could not welcome her in my life, she was not supposed to know that I was desperately seeking help; she was not supposed to know about my stinking carpet or about my masks. But the smell from the carpet was coming out terribly. Her insight, experiences, and most importantly, the Holy Spirit, allowed her to read my mail right in the midst of me trying to hide. Most of all, I was scared that revealing all these things could cause me to lose the only healthy relationship we had established in the previous months, which didn't happen. I did what I knew to do best, shut down and continued taking pills and drinking on and off.

I began to show up for counseling high on pills, numbing myself for an hour or two. Even though through the Holy Spirit she knew I was on some kind of drug, she never condemned or stopped me from coming for counseling, she agreed to help me with no reservations or motives. She accepted me

with ABBA'S love. During the sessions, I began to shuffle frantically with the areas of my life I should invite her into. One session after another, she was helping me, giving me assignments on how to help myself. Through her questions, I knew ABBA was bringing healing to my life. During these sessions, which I was not completely receiving; I could not receive because I was afraid to be completely transparent about my issues. And ABBA was now pulling away my masks.

My cry for help had been answered by this woman—the first fire was beginning to be quenched—and here I was afraid to come out of the elevator when she opened the elevator I had been trapped in for years. I was known to be strong, solving everyone's problems, allowing everyone to dump on me. Fear and identity crisis had taken complete control of me. Rev. Cooper never gave up on me.

Between the times I was getting help, I gradually began to open up; I had realized that I could trust her enough to open up to some things I was dealing with. Life was beginning to look promising. Then I met a beautiful couple from Kansas City, Missouri, Pastor Stuart and Dr. Serita K. Wright. God began to connect me with healthy people in ministry. I saw something similar in them that I had seen in Rev. Cooper. They were happy people and also understood the heart of ABBA, and, most of all, they loved me.

People were beginning to love me, for the right reasons with no hidden agenda. I was beginning to walk in my season of healing and transformation. Dr. Wright and I began to travel on mission trips to Sierra Leone after she was introduced to the country by me. Our relationship was a God ordained one; she loved and embraced Sierra Leone as if she was from the country. She had a heart for God and His people and she showered them with love. Many trips

followed our first one and our non-for-profit organization "Footprints of Grace" was birthed. Her vision and heart for children were the same as mine so we connected very well.

My life in New Jersey had become stagnant—nothing productive was happening at the time. I had left the church I was attending; my parents thought my life was a failure, and I felt hopeless. Again, I went back to the familiar masks, closet, pills, drinks and so on. There was a constant battle to let go of the past but I was not ready to fight all the way. When a door was opened for me to move to Missouri with the Wrights, I jumped right into it. There I was again, running from everything that was going on, leaving the past behind, moving to a new state, starting over—I was happy.

In Missouri, I was received with open arms by the rest of the Wright family. My future looked great. I was involved in ministry, served in areas I was assigned to, but there was a tug of war. The past was

pulling me on one side and the promising future was pulling me on the other side. Again, I completely shut down and I couldn't function anymore. Missouri, my second destination of escape was beginning to look familiar. The demons I thought had freed me had actually landed in Missouri, waiting for me, I suppose.

Dr. Wright and I were invited to a service one evening. I cannot recall who this preacher was as I write this today. Toward the end of the service, the preacher asked for leaders to go up to the altar for him to pray with them.

As Dr. Wright walked forward, she motioned for me to come up with her, and I followed even though something was telling me to stay behind. What I did not know at the time was that this preacher was going to be a part of my history; he was going to help me break free from bondage; that he was part of my healing process, which ABBA had planned long before I got into this mess. My turn came and this

preacher began to pray for me. As he laid hands on me, he began to speak these words;

"God said to me to tell you that you are going to love again; He saw when your heart was broken; He saw when your dress was torn; He saw when you were being raped, you said you hated men and will never marry, but God said He saw your tears, He is replacing your hatred for men with His love for you. Receive healing in Jesus' Mighty Name!"

At the same time he was speaking, I was screaming and screaming and screaming, as tears were dripping down my cheeks. I was in disbelief of this man's accuracy. My secret, my masks, my closet, the carpet—everything that was hidden was being revealed in front of yet another audience at this church. I was terrified to get up from the floor because I felt judged, I felt betrayed by this preacher, but overall, I felt the peace of Abba.

Following the service that night, I explained to Dr. Wright in details what the preacher was talking

about. She proceeded to ask if my parents knew about the molestation, and my response was no. She instantly said we must call them in New Jersey and talk to them.

Terrified, I agreed to make the call to my parents. For the first time ever, I told my parents that their daughter was a victim of sexual molestation. I felt relieved that I was finally able to tell family my hidden secret. There was a complete silence on the other end of the phone. My mom spoke after a pause and first asked if I was sure of what I was saying and also why I never said anything to anyone? My father said nothing. I responded to my mom and said, of course, I was certain of what I was saying; and secondly, I was scared that no one would believe me if I had said something.

Following the phone call, I cried, shocked at my mother's response and her questions, even shocked that my father did not say anything to me. Two days following the phone call, my mom called and told me

she had spoken to the violator in Sierra Leone. She had asked him if what I said was correct and my mom said at first he denied but later admitted to what he had done and he apologized to my mom for his behavior. My mom then said these words to me: "Well…it's been a long time since this happened, and besides, he has asked her for forgiveness and she had forgiven him; he's part of the family, we should move on!"

Again, I was shocked at my mom's reaction, she almost sounded like she felt sorry for the violator than she felt for her child who was the victim. My mom broke my heart this day, and this was more than the hotness I felt when she dashed cayenne pepper into my private when my uncle told her of seeing from coming out from a guy's house. I could not understand how a mother could casually respond the way she was responding to this horrific event of her daughter's life. Smoke, fire, ashes, yet again, I swallowed, choking.

Ten

One of the processes in obtaining a complete healing is revisiting the past to deal with the hurt and pain. We must revisit the trauma, abuse, pain and hurt in order to be free. We cannot obtain complete freedom if we are not willing to accept the hurt or past trauma and the very thing that caused the paralysis in the first place.

In order to start my healing process, I had to revisit the original source that caused me trauma. Months after the conversation with my parents, Dr.

Wright and I planned another mission trip to Sierra Leone.

On this trip, she suggested that I meet face-to-face with the violator and have a talk with him. The thought and idea of meeting face-to-face with this man caused me anxiety and fear all at once. I was totally against it but I knew it was something I had to do. I wanted to be free, but at the same time, I did not want to meet with this man. Facing and confronting him is not something I was looking forward to.

On our arrival in Sierra Leone, we set up a meeting with the violator. Everything was planned; I was going to meet with the man who stole my voice for almost two decades; the man who paralyzed me; the man who has betrayed my trust; the first man who broke my heart. I was terrified and could not sleep the days leading to the meeting. How was I going to feel sitting next to this man? How was he going to respond to me? Was he going to apologize

for what he did? Does he know how my life had turned out to be because of his selfish act? These were a few of the questions that were popping up all at once.

The day arrived and I was having an anxiety attack, terribly shaking, I expressed to Dr. Wright that the meeting should be canceled. She refused and made me understand that I had the opportunity to let the man who hurt me know how he'd made me feel.

My freedom depended on this meeting, and I could tell that this man still had control over my life. Everything that has happened to me was a result of what he had done to me. So having this meeting was important. Larrison came to the house, sat in front of me, and Dr. Wright sat next to me and held my hands. She opened up in prayers and motioned for me to speak. This is the day I had to tell this man how I felt about him. I wanted to tell him I hated him for what he had done to me. I wanted to kill him

slowing so he could feel the hurt I felt deep down inside. I wanted revenge—I wanted him to deal with everything I had dealt with throughout the years. I had the perfect opportunity to unleash my anger on this man. I was trying to reach to my closet again for another mask, but I realized my closet was so far away from me. I began to have an anxiety attack all over again, terrified and shaking.

I began to speak—my voice quaked from fear. Instantly, everything began to flash in front of me. My fantasy world, the hairbrush, that bedroom, the bending position, the kitchen, bathroom, steps, his bedroom….then I felt rain, freedom, peace and a cool feeling overtook my entire body. I looked straight into his eyes and said, "We wanted you here because I've some things to say to you. You hurt me the day you started molesting me. You've done horrible things to me ever since I was a little girl. I have been afraid of you for so many years. I have hated you for so long because of what you did to me.

But today, I am not afraid of you anymore! I forgive you for everything you did to me. You will never have the opportunity to hurt me again!"

I finally took a deep breath after saying all those words. The stress, the fear, the bondage, was instantly gone. Then I waited for his response:

"I am happy this day has come, I am happy you called me to this meeting. I knew I hurt you, I knew what I did to you was wrong. For these things, please forgive me for what I did to you."

I was silent. Dr. Wright interrupted my silence with a question, "Do you forgive him?" Even though I had told him I'd forgiven him, I had to really think about it. I took a long look at him and said, "I do forgive you." He smiled and said, "Thank you."

We closed in prayers and he left. I had faced this man who molested me for the first time after so many years. I was beginning my healing journey on

this day. I felt great, I felt happy, then I saw a light, then I saw my future—the new me.

I had never understood the power of forgiveness until the day I sat face-to-face with the violator. I had to come to terms with reality. He had a great life—he was married with children, doing well for himself. He was and still is part of our family with this secret. I, on the other hand, had gone through so many traumas all because he had taken complete control of what was happening to me because of his act. I had unconsciously given him too much power over me. With or without my forgiveness, he was living a great life. He was not thinking about me or what he'd done to me in the past.

I have heard in time past about how "forgiveness is for you and not the person who caused the harm" but I did not fully understand what that really meant until the day I told him I had forgiven him. I looked back and recognized what unforgiveness had cost me. It had cost me years of pain, trauma, and

heartbreaks and so on. It had paralyzed me from moving on and hindered my complete freedom. I was holding on to something that I could've let go.

In order to begin my healing journey, I had two choices. I had to choose "life—which was letting go completely of this original hurt and live," or choose "death—continue to feel sorry for myself and die." I chose LIFE.

Months after our return to the United States, I moved back to New Jersey and reconnected with Rev. Cooper. This time, I was ready to be completely transparent, I was ready to peel off the masks, raise the stinking carpet all the way up, and burn the closet with every mask inside. My willingness to be completely transparent was my greatest breakthrough.

Eleven

I returned back to counseling and seeking help with a different mindset. In order to completely be free, I had to transform my thinking completely. I had another decision to make, and that was to shut off the voice that was constantly discouraging and telling me negative things about myself. I had to abort that voice that was pulling me away from being completely healed. Along with Rev. Cooper, we started very intense counseling sessions. Rev. Cooper used her skills and experiences and series of ways and methods to help me move on.

My first assignment was to make a list of my past hurts. This process was going to help me but I was not sure how. Writing down those things, people and places that had caused me hurt and pain, was not easy. At first, I had difficulties making this list. I could not bring myself to write what had caused me so much pain and hurt. When I could finally sum enough courage to do so, I sat down with a pen and paper and began to write:

1. The violator caused me pain and broke my heart.

2. The strings of men that caused me pain and broke my heart, including my father.

3. The series of women.

4. My own anger, bitterness, and unforgiveness that I had held on to.

5. Addiction to prescription pain killers and alcohol.

The list went on and on. By the time I came to the end of it, I began to feel different. I reread

everything on the list over and over again. Line after line, I saw how much power I had given these people and things.

Again, everyone on my list was happy while I had given them so much control and power over my happiness. Making a list of my past hurt, pain, and trauma was a great tool to help me walk in complete healing.

Secondly, I had to accept the past and realize that it was never going to change. The fact that I was molested was never going to change; the fact that men broke my heart was never going to change; the fact that I was involved with women was never going to change; the fact that I had a drinking and drug problem was never going to change—I had to accept these things.

During a session of acceptance, Rev. Cooper asked me to verbally say some things in order to move on to the next step. One of the things I had the most difficulty saying was "I was dealing with the

lesbian spirit." I could not bring myself to admit that I was dealing with this issue. I was not a lesbian, but for many years I operated in that spirit and I had to accept that part of my life. Saying these words out of my mouth was difficult.

Rev. Cooper sat and waited for me to say these words for almost an hour. I don't know if she was patiently waiting or impatiently waiting for me to just say those words. Either way, I am grateful that I went through that session. I finally said those words and realized afterward that it was as easy as confessing and accepting all the others things I had to previously say.

It was the most helpful moment as part of my healing process. I stopped arguing with my past, accepted everything that had happened, recognized that they were not going to change, and took the chance to do what I could to make a difference. And that's what I am doing now—living a bold life, impacting lives with my story.

Thirdly, I had to be accountable for some of what was happening to me. Not only that, I was also accountable to God and Rev. Cooper. I had spent so many years blaming everyone and everything going on at the time. I could not fully understand why I had to take responsibility for the effects some of my actions had caused. I was totally selfish and threw the blame on everyone else but me. I had spent so many years doing everything to sabotage my own life. I was not accountable to anyone and that was one of my biggest downfalls. No matter what I did, I was always on my own. Rev. Cooper, my counselor, became the one I was accountable to. Her discerning spirit is very sharp.

When she recognized my tactics, she became familiar when I walked into her office high on pills. She was never wrong even during the times I denied her confrontation. I had to be accountable for my actions.

To this day, she recognizes when I'm not myself even when I choose not to share anything. And I am grateful to her for being there when everyone left me. That's how God uses people to bless us.

Finally, I had to let go and make peace with the past. How do you begin to let go of so many hurts, trauma, and pain, how do you make peace with your past? In letting go and making peace with my past, I had to begin to peel off the masks; I had to spit out years of fire balls, smoke and ashes. This was also a challenging and nervous process. Peeling off the masks was taking a risk and allowing others and even myself to be reintroduced to me.

I had lost all my identity; having to make peace with the past meant I had to find out who I really was. My identity was filled with a closet of false identities. It was clustered with a nasty stinking carpet that was badly decomposing; it was also being suffocated with the masks that had been stuck on my face for so long. One by one I began to peel off the

masks, clean out the closet, got rid of the carpet completely. The process was intense. At times I felt insecure and naked without the masks, as I was so used to, which everyone was familiar with. I lost all my friends because they could not fit in the new me I had become.

Following this process, Rev. Cooper bombarded me with scriptures the moment she realized I was willing to walk through this healing process, assured that I'd made up my mind to finally be free. Freedom felt great, my cry for help was finally heard, and ABBA came to my aid.

Because I was struggling with so much rejection, I could not accept ABBA's love for me. All the scriptures I was given and meditated on were very helpful. I began to see myself as ABBA saw me. My life began to matter. And it was all because I took a leap of faith and ABBA turned my tears into joy.

During the time I was receiving counseling, I attended my current church on and off. I attended

their annual conference International Pastors and Ministers Conference (IPMC).

The first night I walked into the church, I was bombarded with so much love coming from the pulpit. The messages that were being preached were all new and confusing to me. I was introduced to a new message entitled: The LOVE and GRACE of ABBA.

I began to hear messages from the pastor about God not being mad at you because of sin; messages such as, 'God loves you no matter what; God's heart desires were to bring you to a great end in spite of what your past was."

I was blown away by this message of love and grace. In my past experiences in church, I was told that even if we were saved, if and when we sinned, we were going to hell. I was spending all my time asking for forgiveness, feeling rejected by the Father, and because of that, I had no relationship with him.

I was first introduced to the love of ABBA by my counselor, and then I walked into a church where everything made sense to me. I received counsel right from the pulpit from a man who didn't know what I was going through, but his teachings were helping me every time I walked into that ministry. Faith Fellowship had become my home for many years to this day. Pastor Demola, thank you!

Twelve

There had been so many times past when I was furious that I went through so much pain. I was angry at God for so long because I felt like it was His fault all these things happened to me. I felt it was His fault because He knew I was going to do all those things and did nothing to stop me from going there. On the other side of the coin, I was also mad at myself, because I'd not disciplined myself; I'd not read my Bible and prayed as I should've done. What

I didn't know at the time was that He was preparing me for the assignment he had for me.

As I conclude, I want to share something about purpose with you. King David had a purpose on his life. He was on the back side of the desert, killing wild animals, rejected by his family, but God sent Samuel to anoint him as king.

Queen Esther had a purpose, she married into a family that she did not belong to, but saved her generation because she had a purpose.

Most importantly, Jesus had a purpose. He was sent to this earth to pay a one-time price that saved you and me and blessed us with eternal life if only we'll accept Him as our Lord and personal savior.

Are you mad at God because of the challenges you are facing today?

When I was two years old, I was diagnosed with a heart condition, as my mother explained it to me. I was not supposed to live past my second birthday

because I was not going survive the heart condition if surgery was not done.

My parents could not afford the money for surgery so I grew up in Sierra Leone with a heart condition that could have killed me. But, I had a purpose! Everything that you have read about me so far was all leading to what God was preparing me for.

I had my first open heart surgery that could have killed me in 1999; I had a second one in 2014, and the third in 2016. I had a purpose, so dying was not an option.

Is your past hindering you from moving forward to what God has called you to do? Who or what has silenced you? Who or what is breaking your heart? How many times have you cried for help and no one listened, or the wrong person or people got a hold of your information and used it for the wrong reason? Or are you wearing the mask pretending to be something or someone that distract others from who

you really are? What masks are you wearing that have fooled everyone from who you really are? Or maybe you are the one trapped in the elevator pressing the help button wishing someone will run to help?

No matter how rough and tough it is now for you, know that God is in total control of your life. Have you ever heard the saying "Your misery is your ministry?" Anytime I hear this, Nehemiah comes to mind. When Nehemiah heard that his people were living unprotected in Jerusalem, he was inspired to go and save them.

"And they said unto me, the remnants that are left of the captivity there in the province are in great affliction and reproach: the wall of Jerusalem also is broken down, and the gates thereof are burned with fire. And it came to pass, when I heard these words, that I sat down and wept, and mourned certain days, and fasted, and prayed before the God of heaven."— Nehemiah 1:3-4.

He could have sat there, worried and sad, and blame God like I did when it got to a certain point in

my life, but he cried unto God. And Nehemiah didn't just cry, he decided to rebuild the wall. His misery turned out to be his mission. God uses difficult situations to cultivate His purpose in our lives, and to open our eyes to His power in us. So, whatever you may be facing now is for your good. Keep your head up, keep praying and focus on the word of God.

I pray that God will direct you to the right person, or people that will help you break free from your bondage. I'm praying for and with you. Be blessed as you begin your journey to freedom!

Conclusion

The job of Firefighters or firemen is to put out fires and rescue people. As you know, there are several firefighters in cities and towns throughout the country. The fire truck pumps water and foam which is used to put out the fire. Fire trucks carry ladders and tools to help rescue people from burning buildings and also first aid kits to help people who are injured or hurt.

Anytime I see the fire truck blowing the siren and speeding all through the streets just as the ambulance or the police do, I always give them a way

to pass if they happen to be on the road that I may be driving on. It is good that we have put in place all these measures to help rescue people; it is also great to have an emergency code that you can dial in a few seconds when there is fire in your house. But what do you do when there is fire in your body, spirit, and soul? Would you still pick up your phone and dial the Fire Service Emergency code? Of course not. This evidently shows that the Fire Service in our country has a limit.

Maybe you are in some fire right now: You have been married for years and you are trusting God for a child, but it seems it is never going to happen. You are not alone. In Genesis 17, a certain man called Abraham and his wife, Sarah, faced the same challenge. God paid them a visit one day and told him that he would become the father of many nations, but to the couple who were in their nineties, it sounded like a joke. Genesis 17: 17 tells us that, "Then Abraham fell on his face and laughed, and

said in his heart, "Shall a child be born to a man who is one hundred years old? And shall Sarah, who is ninety years old, bear a child?" In verse 12, we also learn that Abraham was not the only one who laughed at the promises of God; Sarah laughed too. "Therefore Sarah laughed within herself, saying, "After I have grown old, shall I have pleasure, my lord being old also?"

Now put yourself in the shoes of Abraham and Sarah. You are in your nineties with no child and God tells you that you are going to be the father and the mother of great nations, how would you feel? Obviously, you'd be laughing at God just as Abraham and Sarah did. There would be some doubts in your heart considering your age. Abraham and Sarah felt the same way. It was all right for them to laugh because, logically, what God said was out of their way; it simply looked impossible, forgetting that "With God all things are possible." —Mark 10:27. So God asked Abraham—Genesis 18:14, "Is

anything too hard for the Lord? At the appointed time I will return to you, according to the time of life, and Sarah shall have a son." And did Sarah have a son? Oh yes, she gave birth to a handsome male child called Isaac.

Maybe you are David and facing some giant Goliath. You have been sick for years and you do not know whether you are ever going to get healed. Maybe you are thinking this giant sickness is going to defeat you, thinking it's sending you to your grave, looks as if the fire is actually going to swallow you this time. No, this isn't the time for you to live with a defeating mentality. This is the time to believe that with God all things are possible. You are more than a conqueror.

Or maybe you are Martha living in New York City and your brother Lazarus is sick. You have heard that Jesus Christ, the son of God, is in town. You have even called him, and it looks as if Jesus is just dragging his feet, not heading to your house the

131

very moment that you need him—and you are wondering whether Jesus cares at all? I know how that feels.

Maybe you have the same story as Martha in John 11. Maybe something or someone so dear to you is dead. Maybe your parents are separated, and you are not sure how your life is going to turn out? Maybe you have dialed Jesus' emergency code and yet, he hasn't answered. Do not lose hope, just keep dialing.

When Jesus got to Martha's house after the death of Lazarus, Martha, the sister of Mary, had lost hope. She quickly went to meet Jesus and said to him, "Lord, if you had been here, my brother would not have died.

And Jesus said to her, "Your brother will rise again."

Martha looked him in the eye and said, "I know that he will rise again in the resurrection at the last day."

Jesus said to her, "I am the resurrection and the life. He who believes in Me, though he may die, he shall live. And whoever lives and believes in Me shall never die. Do you believe this?"

She said to Him, "Yes, Lord, I believe that You are the Christ, the Son of God, who is to come into the world."

Never stop believing. In your dark days, surrender all your burdens to Him. Martha could not believe that Jesus of all people could allow Lazarus to die. *Why let someone or something die when you have the power to save it?* But Jesus did not only raise Lazarus from the dead, he also taught them to trust God in all situations.

When you face a tremendous challenge which is beyond your capabilities or when you face a situation that cannot be met by human means, you ought to learn to trust God's timing. Because time belongs to Him, so even if it looks as if He is delaying, He

knows best. Do not let your fears cause you to keep your eyes on your problems. Instead, keep your eyes on God.

I do not know the fire that you are swallowing now or you have swallowed over the years, but I want you to know that God is your Fire Service. He is the one who can put out the fire in your life if only you will dial his emergency number through prayers, and keep being patient even if it looks as if he will never answer.

He sees our hearts and knows our thoughts. He is aware of all that you are going through now like it happened in Lazarus's case. When he arrives, you will be fine. When he arrives, what is dead in forty years, in four years, in four days will resurrect in a twinkle of an eye. So I encourage you to keep sowing the seed of faith. Keep praying bold prayers, knowing that God will never forget or forsake you. "See, I have inscribed you on the palms of My hands;

Your walls are continually before Me."—Isaiah 49:16.

No matter what has happened to you, you still have in you all it takes to be all that God wants you to be. In your genes right now are His favor, His talent, His Wisdom, and His ability. You are fully equipped.

Keep staying in faith no matter what has come against you, at the right time you will fulfill your God-given assignments.

I hope that through my story you will have faith and believe God for a miracle whatever you are facing right now.

Shalom

~Iya~

Endorsements

I have known Rev. Cole for many years. She is a daughter to me, and secondly, a personal assistance in my Apostolic travels and Missionary work. She has served in many ministries and churches and continues to serve in different capacities.

'THE GIRL WHO SWALLOWED FIRE' is her story, how she got saved and is being used by the Lord after dealing with unbelievable ordeals, full of neglect and torture, resulting in pain, hurts and bitterness.

Voicing out these occurrences in a book is a great deal of an emotional outpour, which is a healing balm for many who have being through or going through the same ordeal. Due to cultural discrimination against women and, wrong or negative perception about women by the society,

many are going through physical and emotional suffering in silence.

Ms. Cole was once a Muslim but now a Christian. She is a worshipper and a teacher of the Gospel—an astounding, versatile and talented believer in the Kingdom work. She has an extraordinary grace in the prophetic area of divine plans and purposes in the life of individuals, churches and nations.

This book is a voice for the voiceless and a cure for all that are emotionally hurt and are held in bondages. I recommend it for every Pastor, church, Para-church and counselors.

—Apostle Dr. Raymond K. Akam

(Founder & Chancellor)
Universal Bible College and Seminary, Italy

To contact

~Iya~

Email: iyatunde03@gmail.com

Website: www.IyaIam.com

Facebook: The Girl Who Swallowed Fire/
Iyatunde Cole

Instagram: @salonepekin

Twitter: @worshiper33

NSOROMMA [STAR]

"Child of the heavens"

Symbol of guardianship

[GHANA]

A reminder that God is the Father and watches over all people.